G000022544

You need to make your art

The Artist's Way for the 21st century

Steven Stone

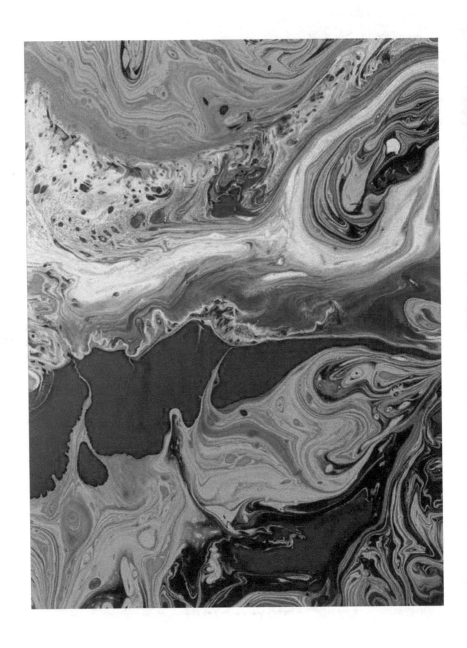

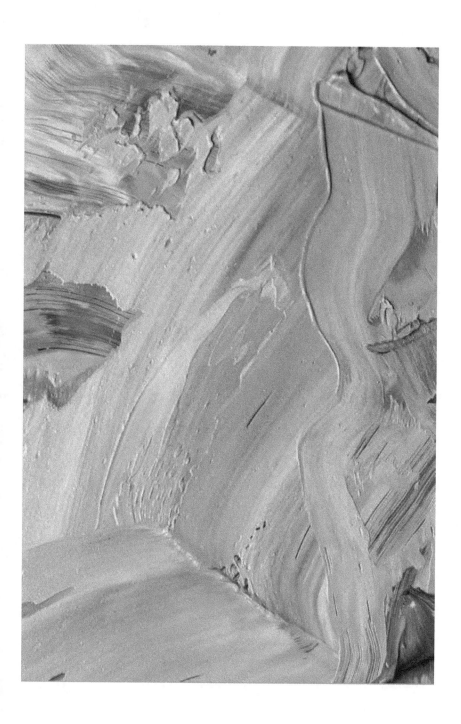

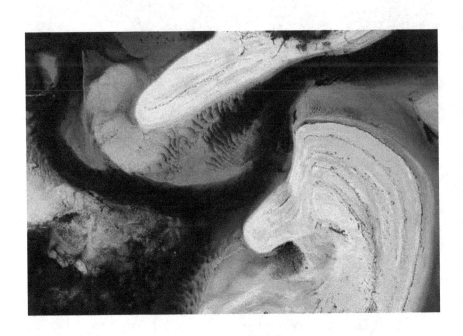

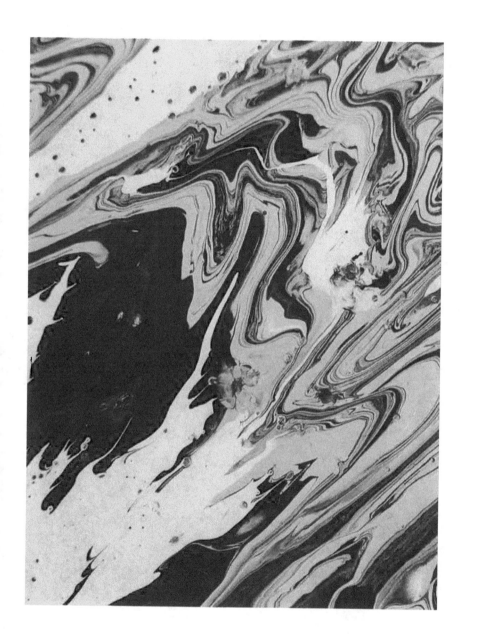

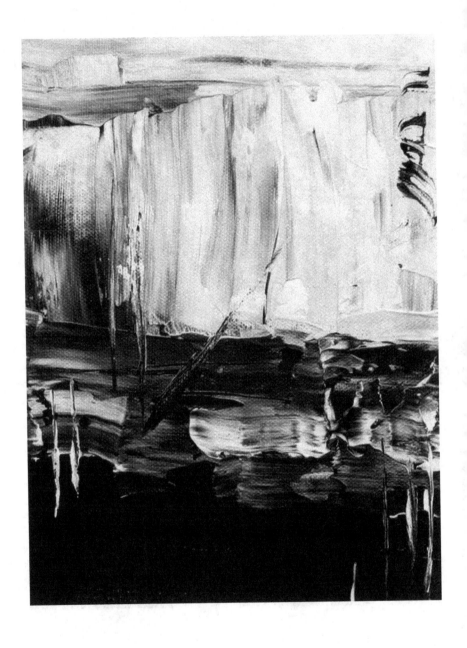

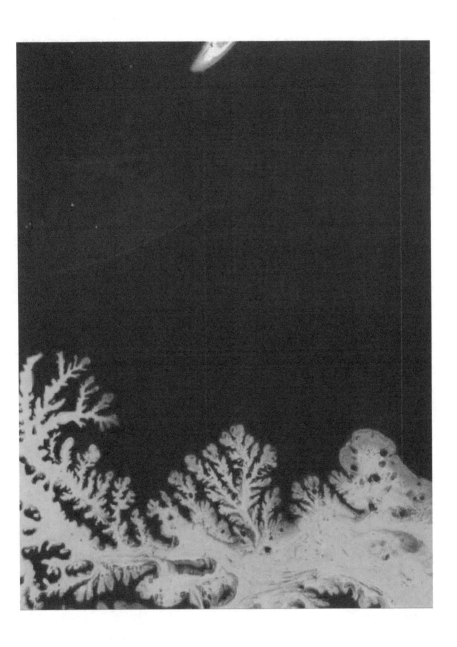

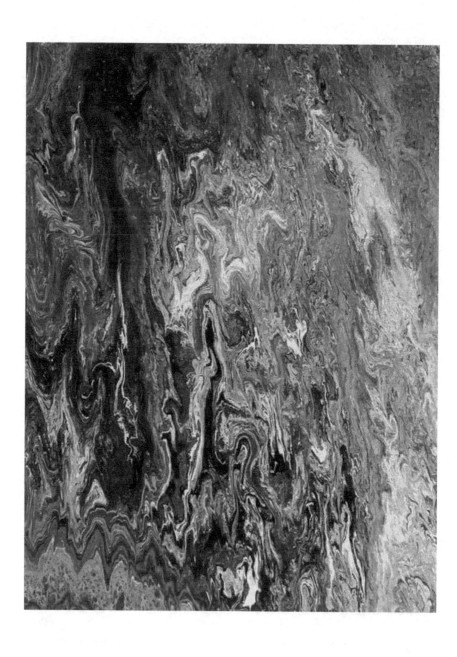

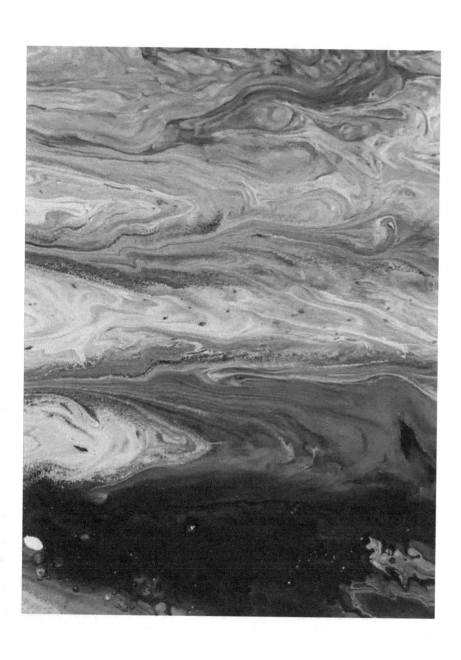

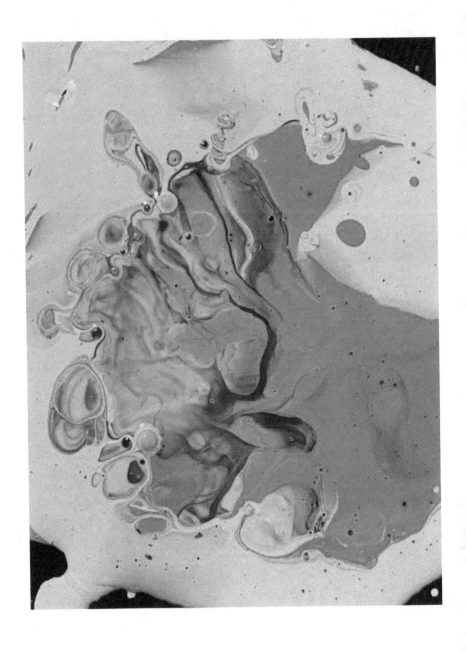

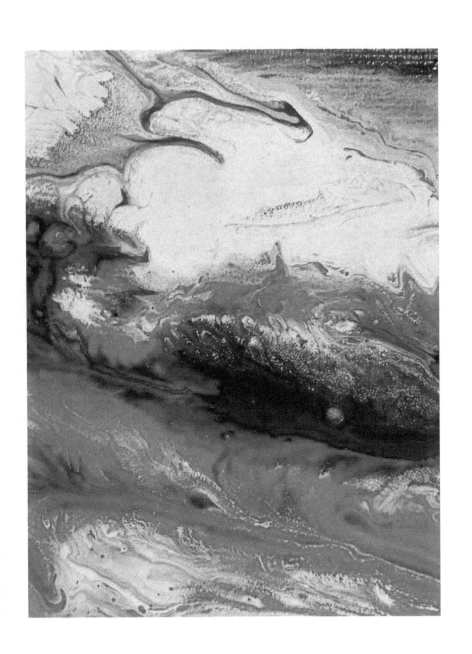

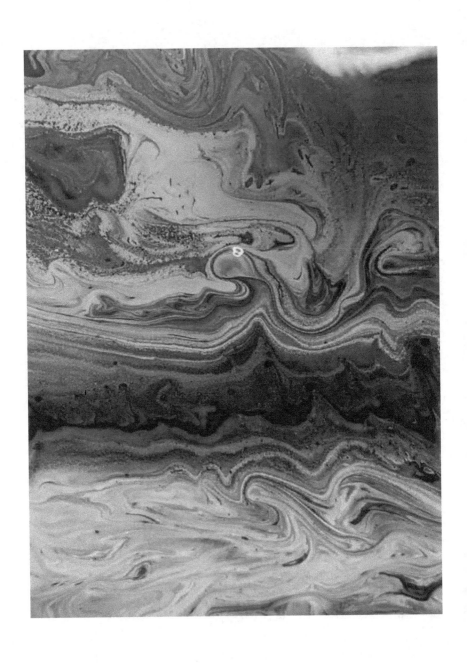

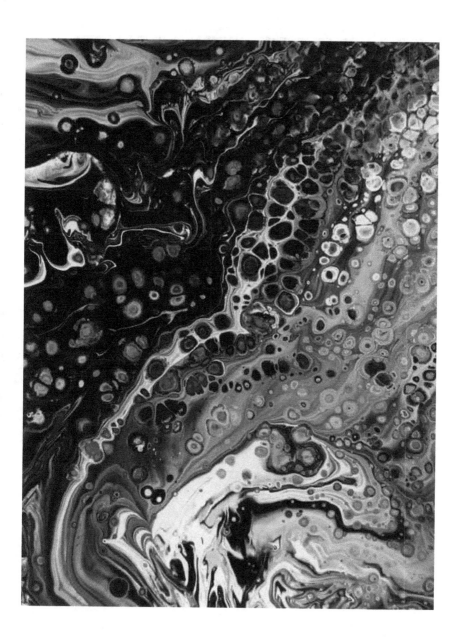

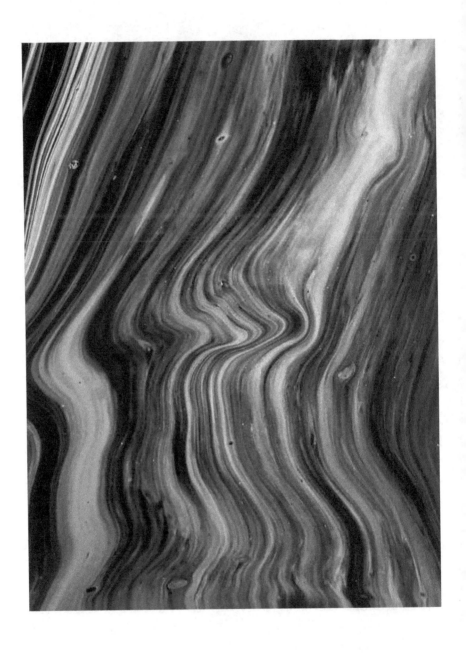

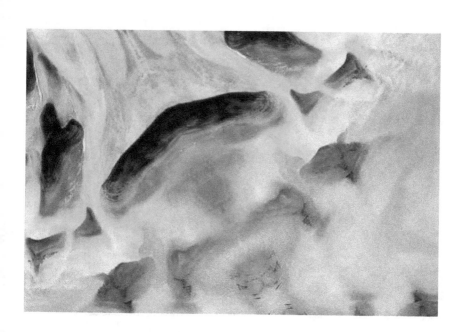

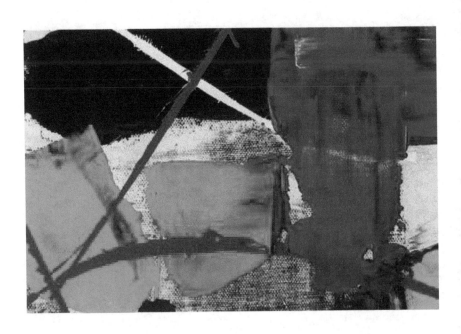

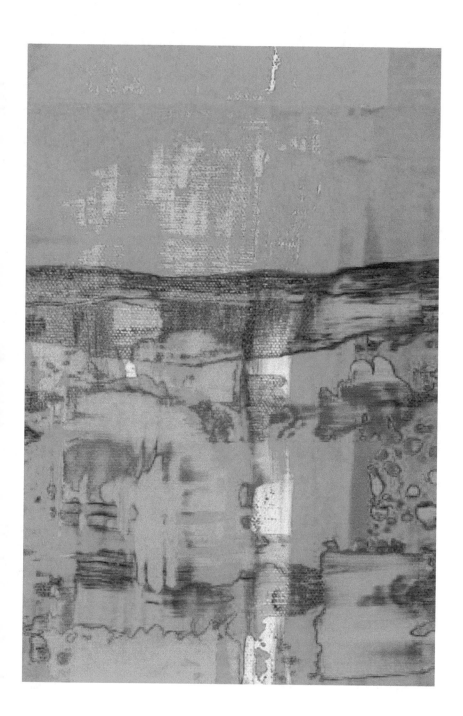

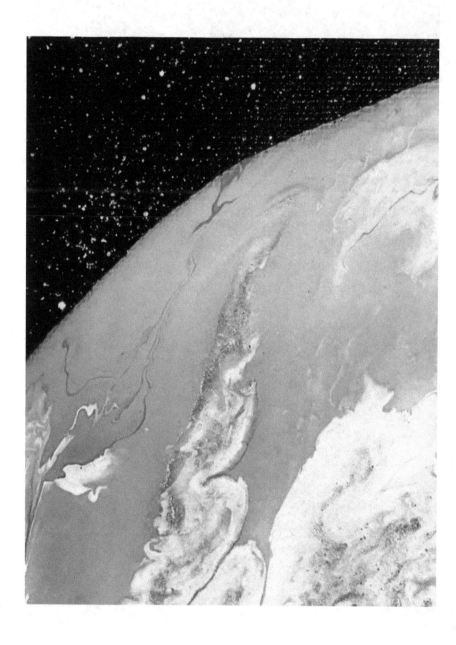

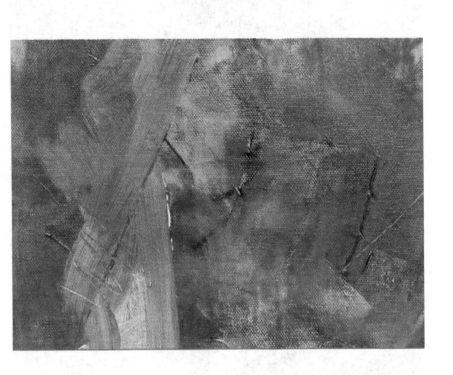

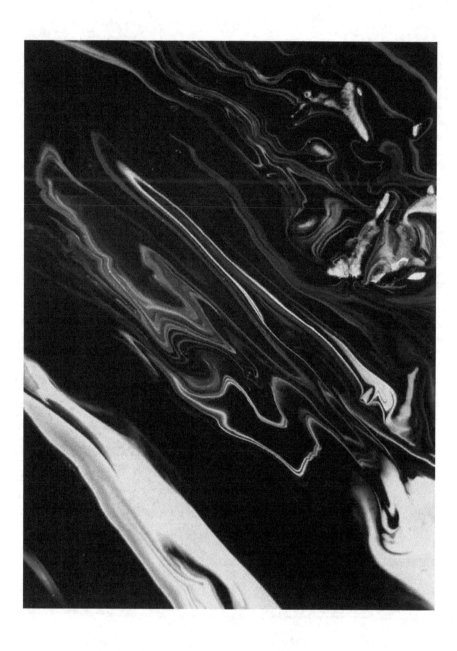

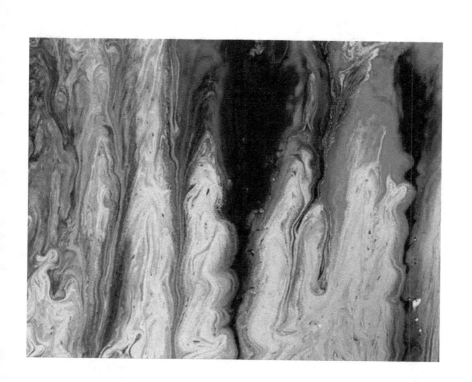

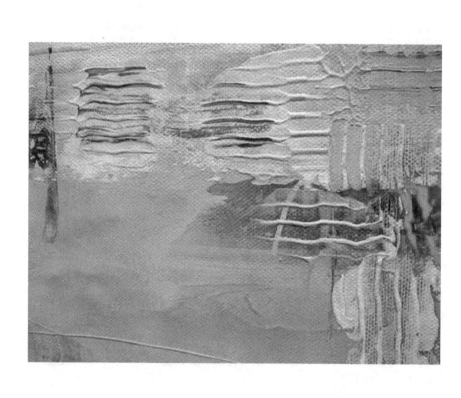

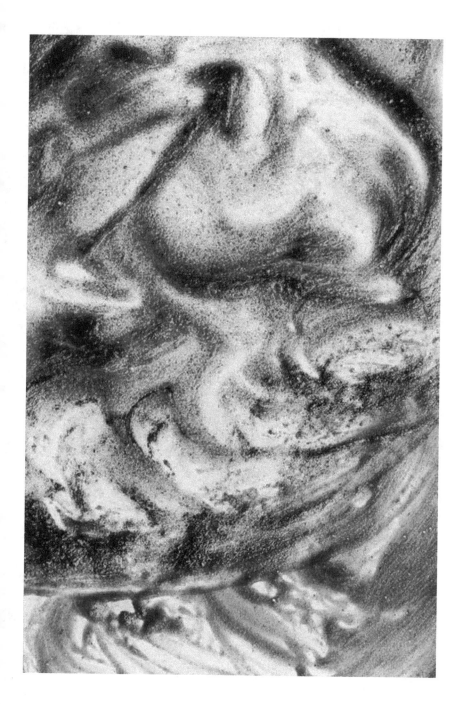

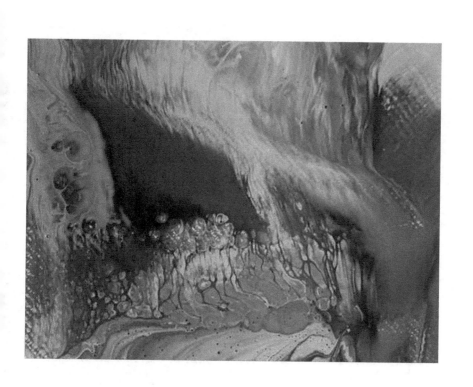

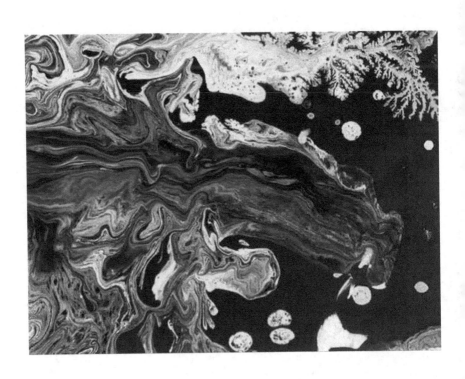

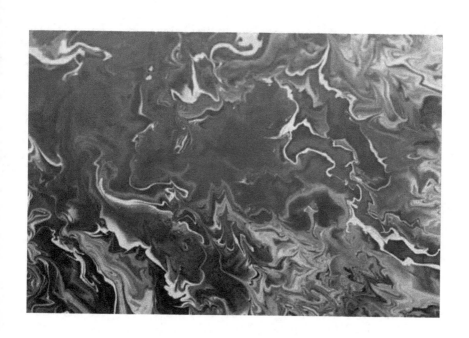

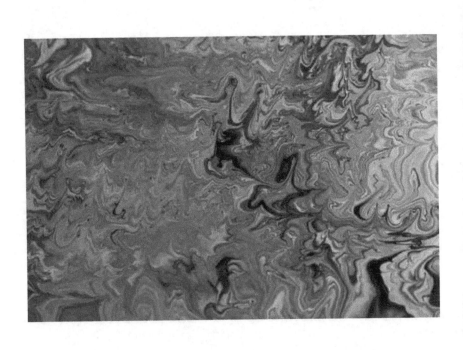

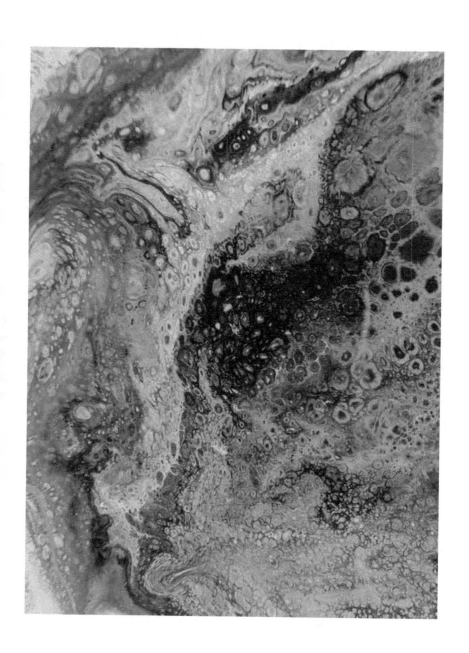

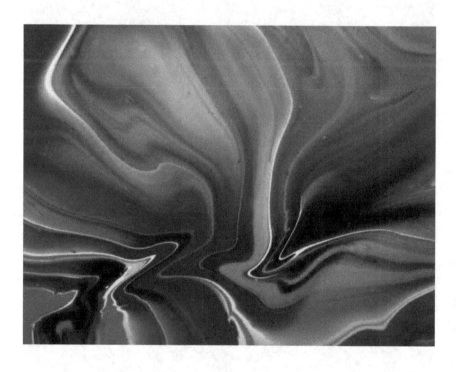

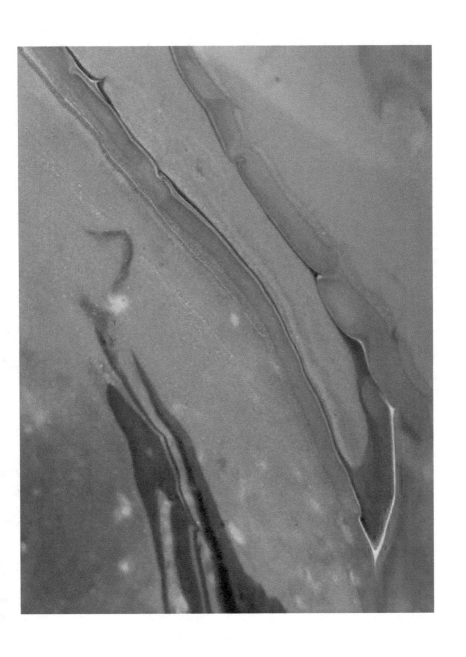

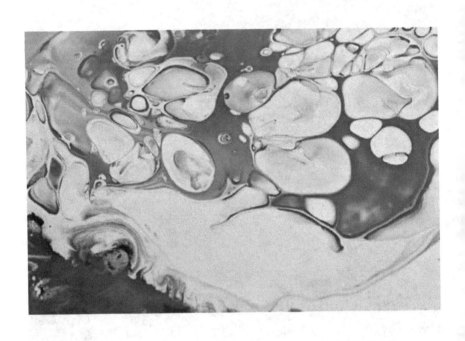

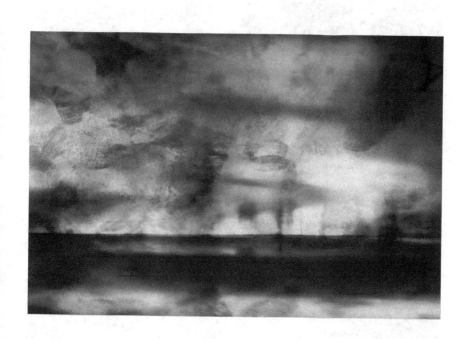

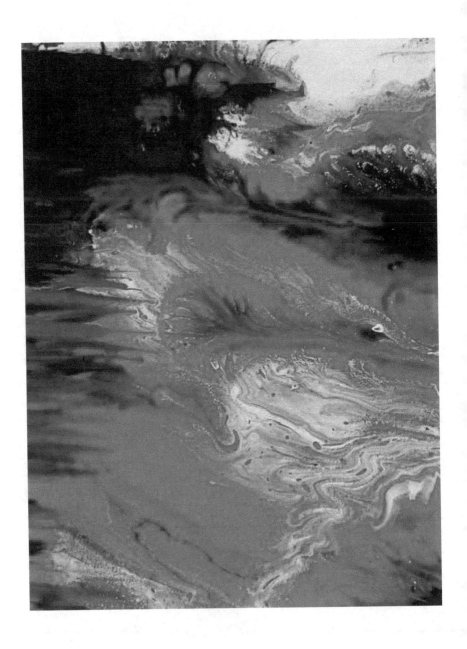

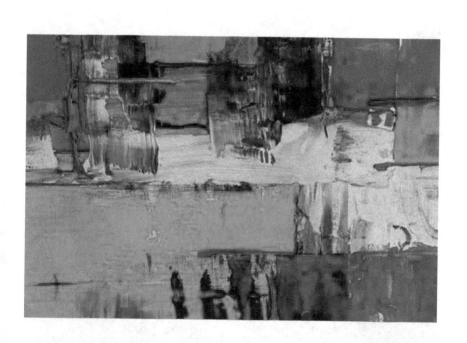

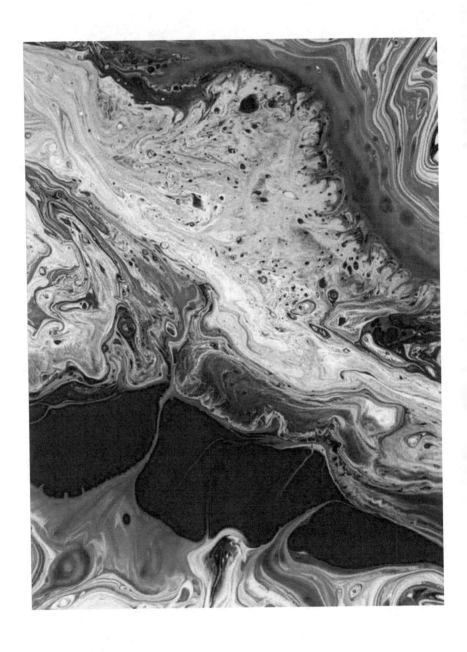

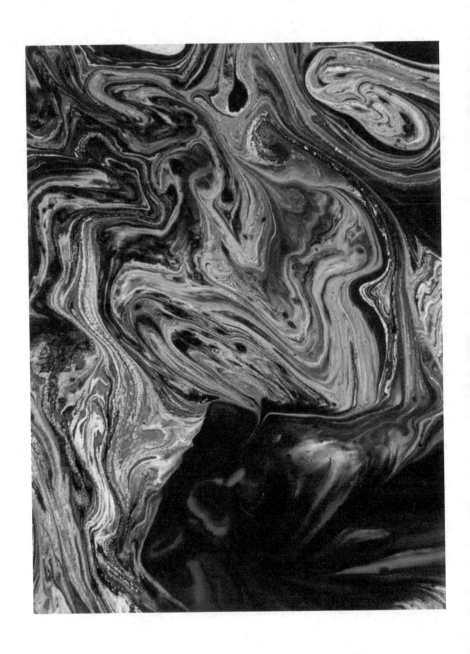

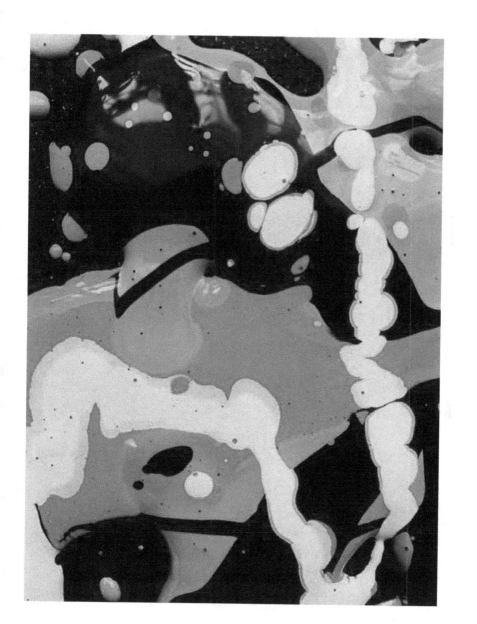

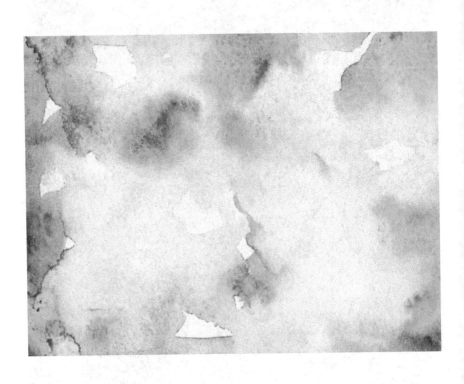

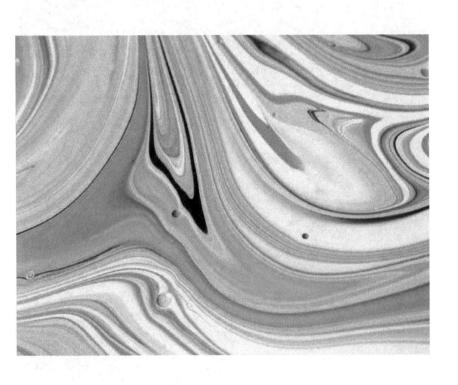

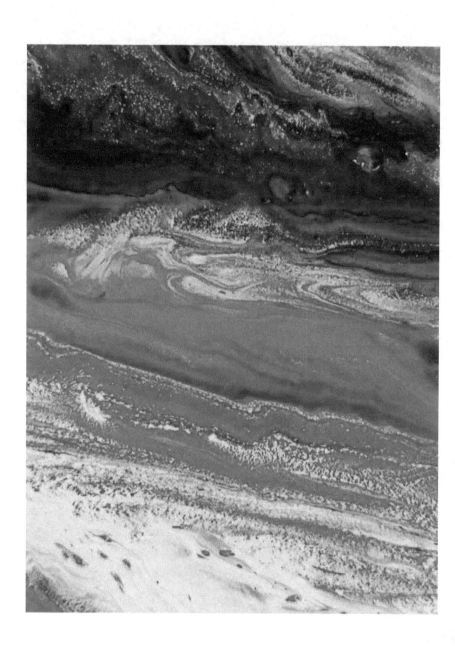

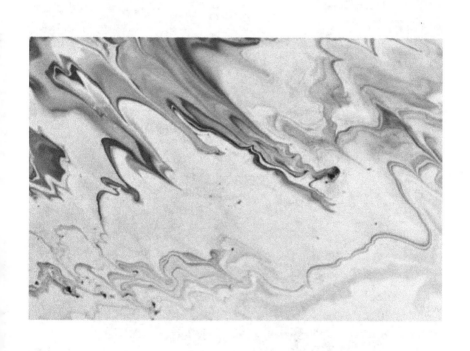

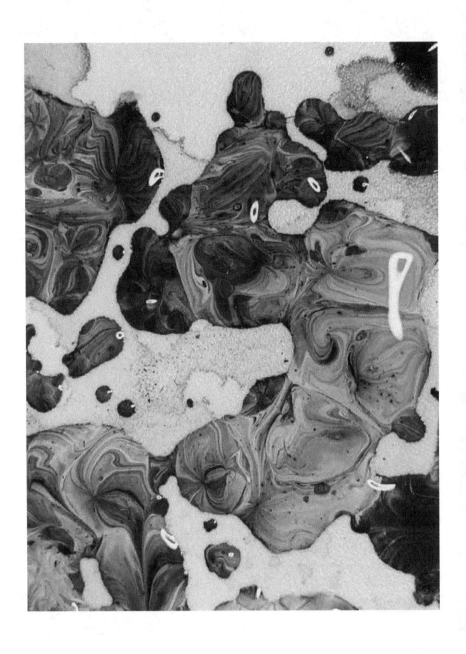

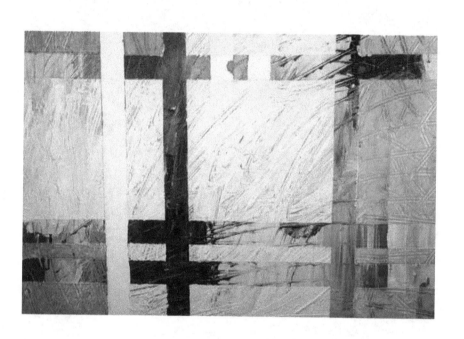

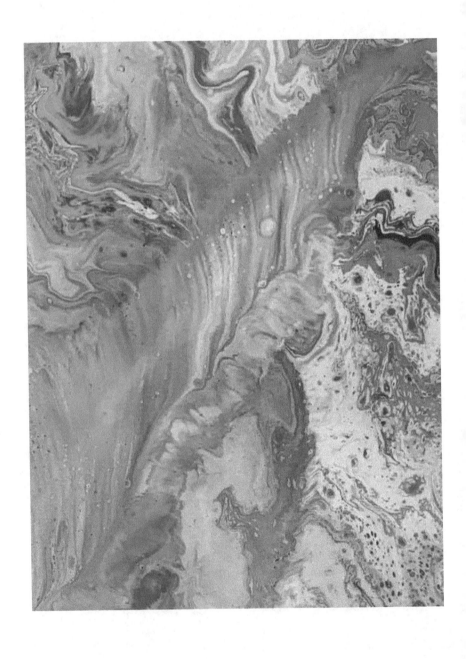

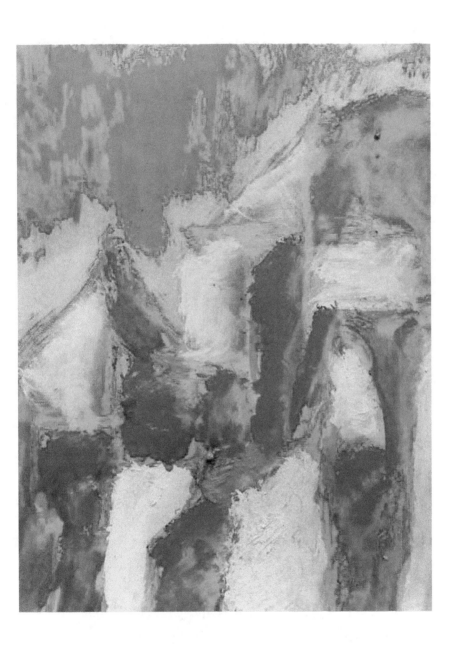

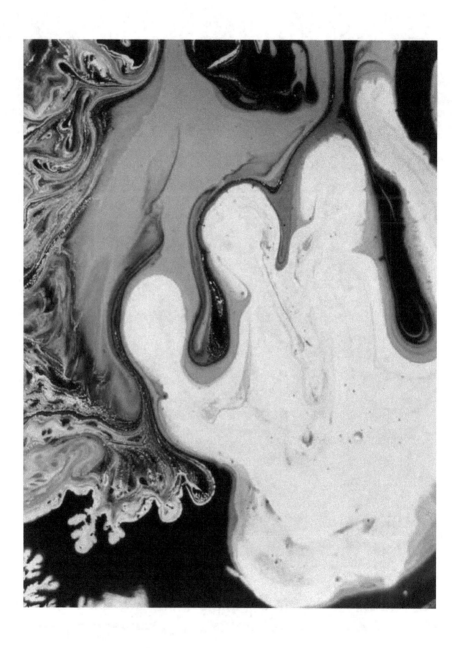

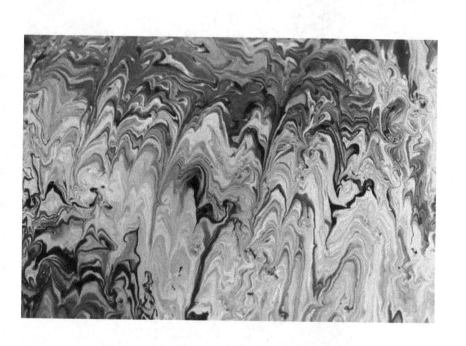

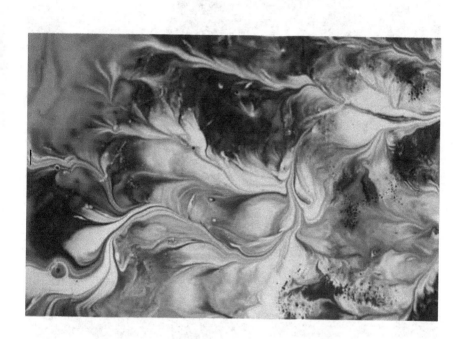

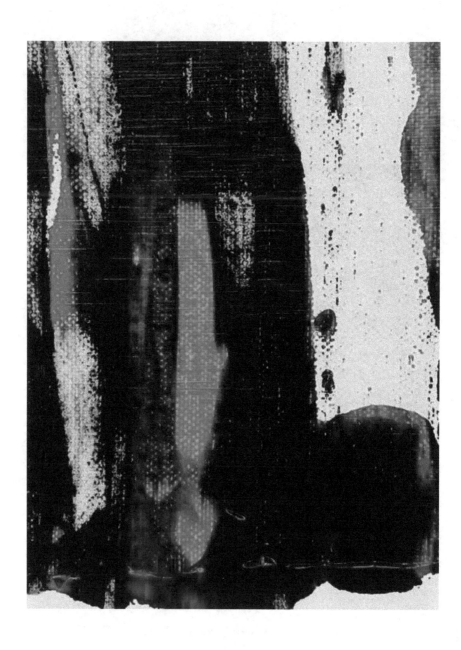

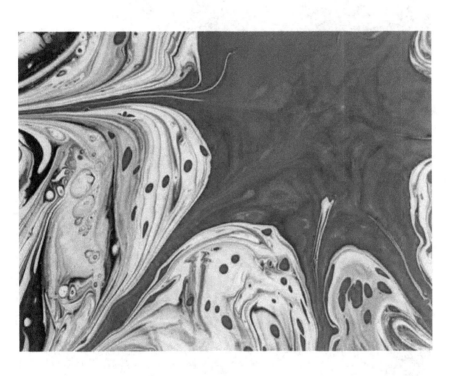

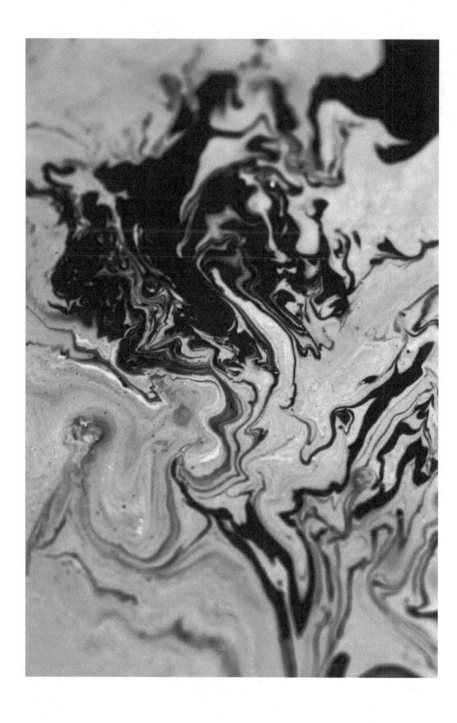

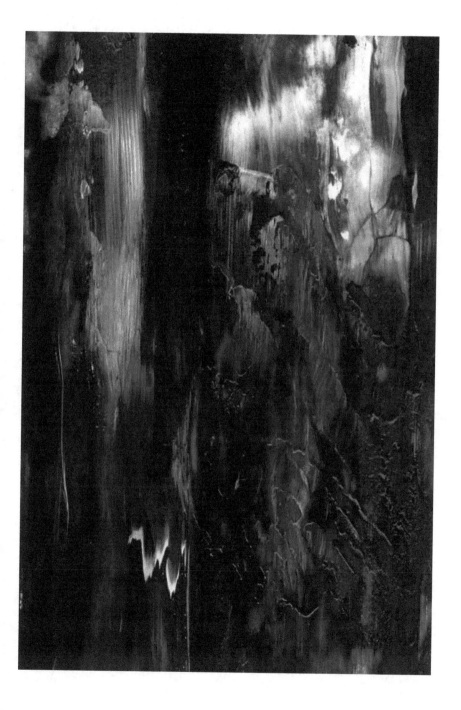

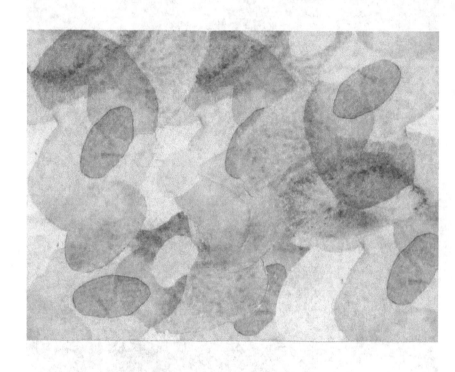

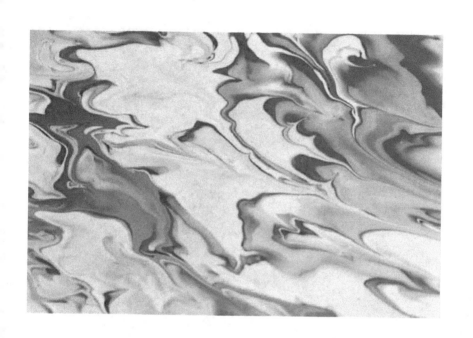

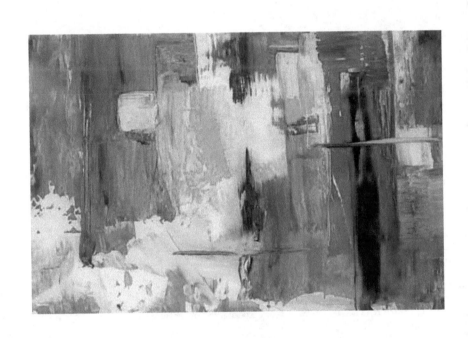

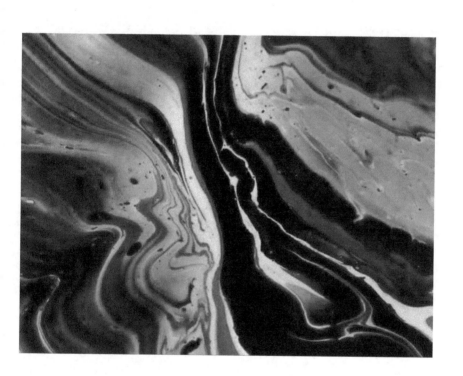

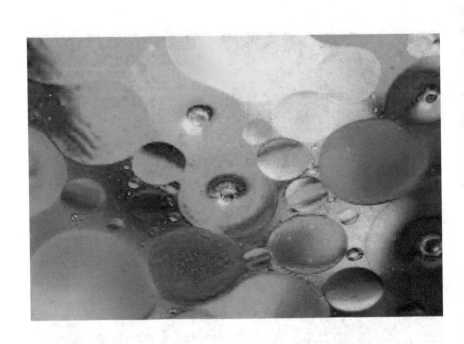

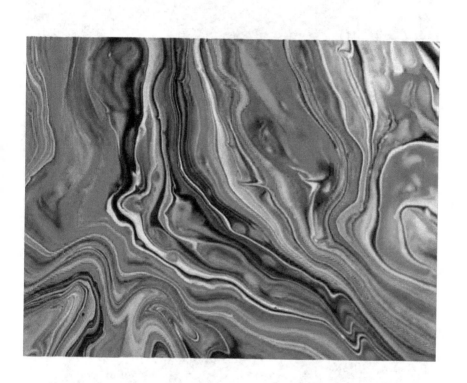

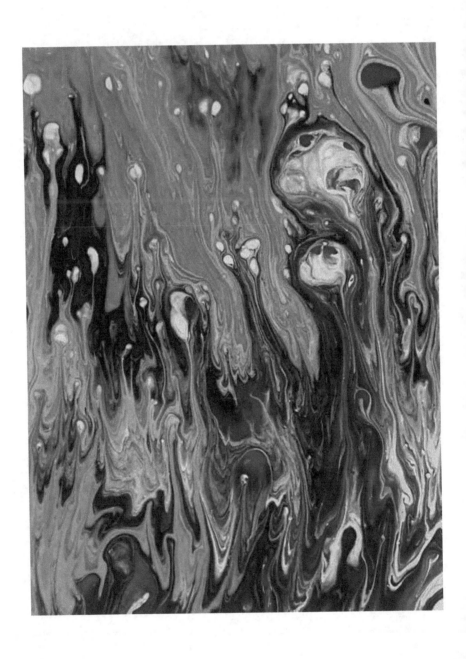

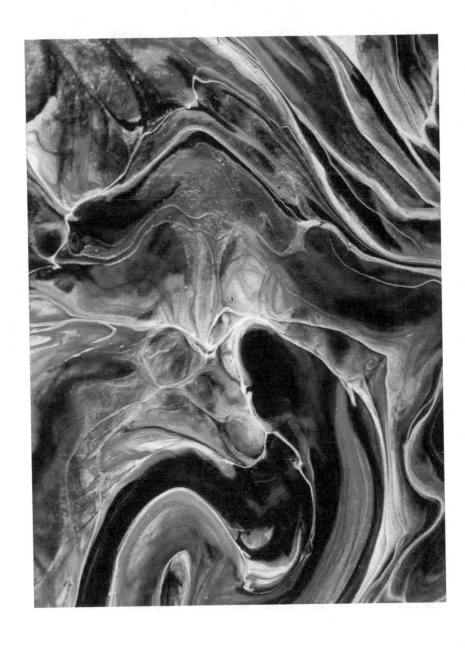

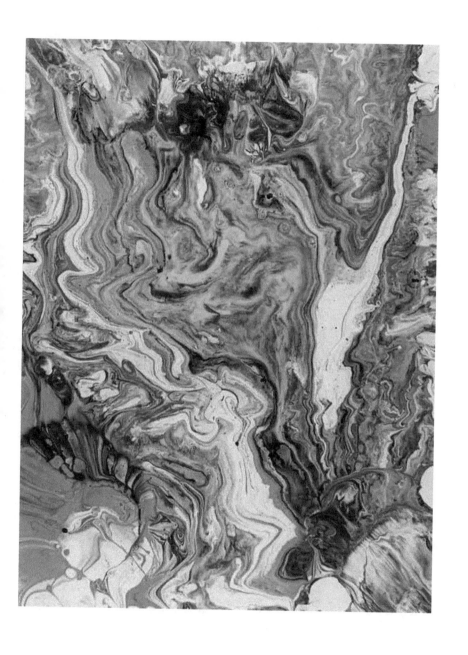

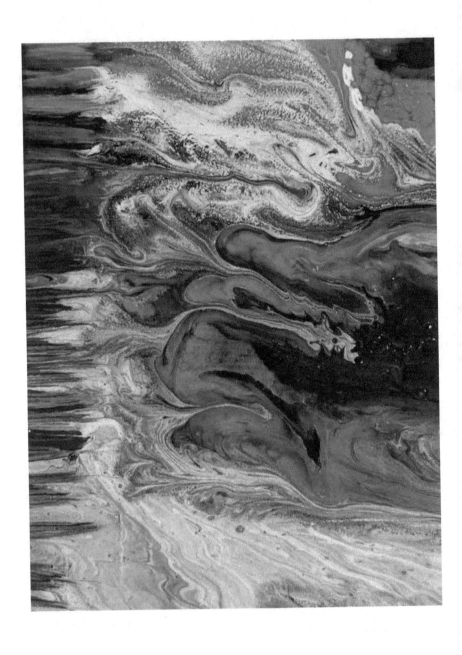

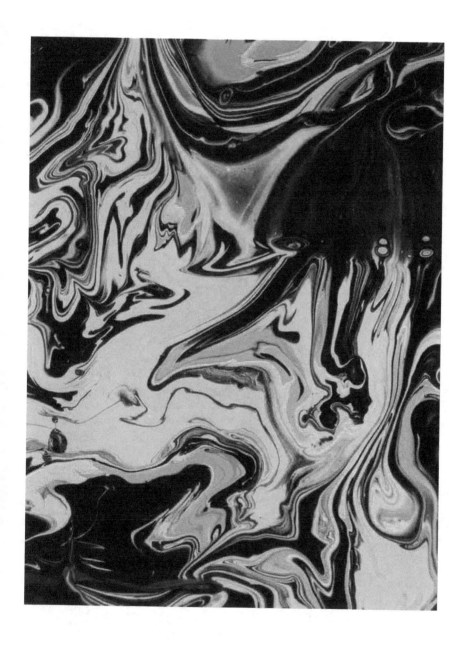

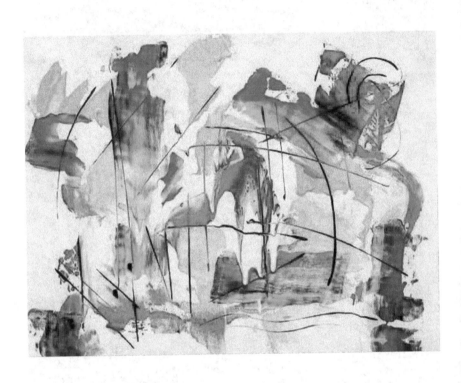

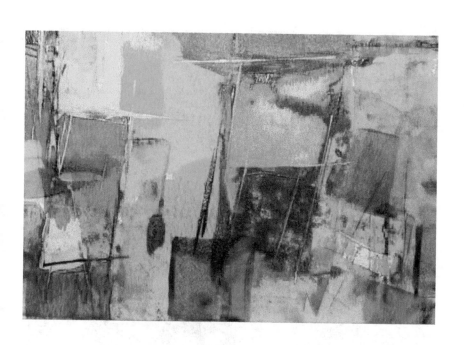

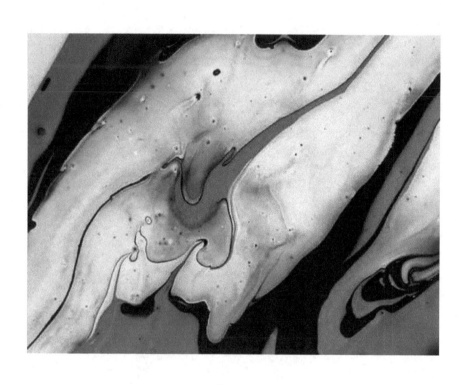

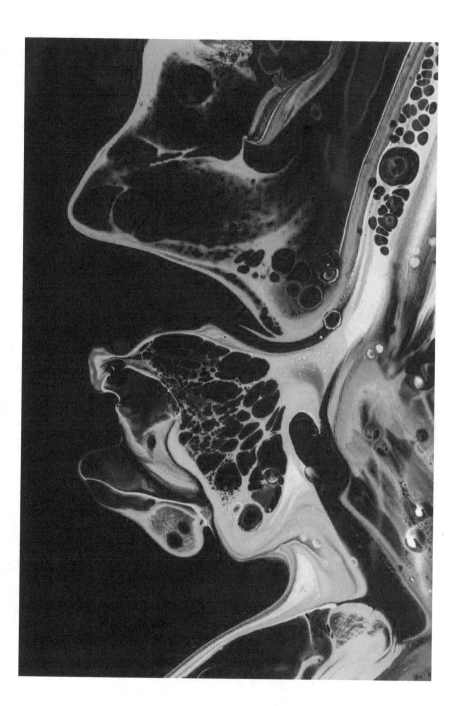

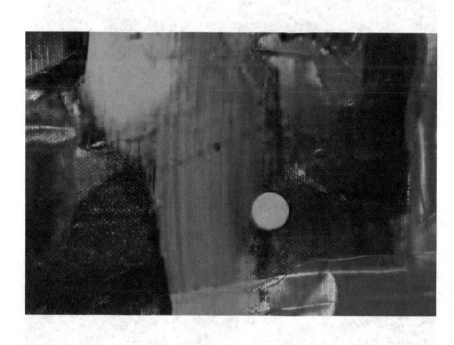

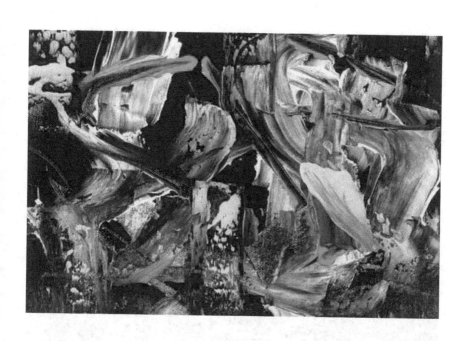

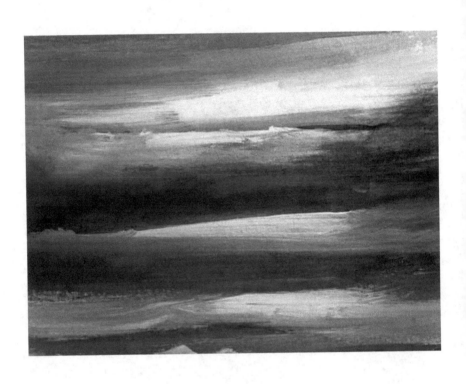

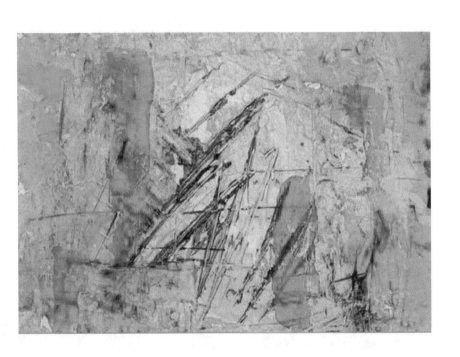

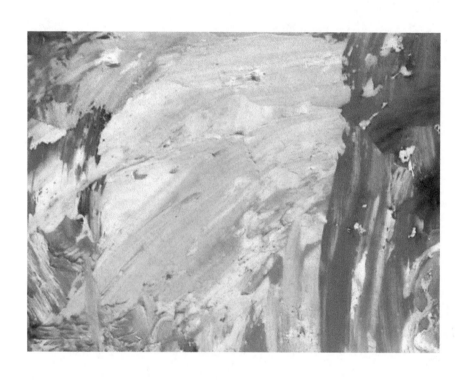

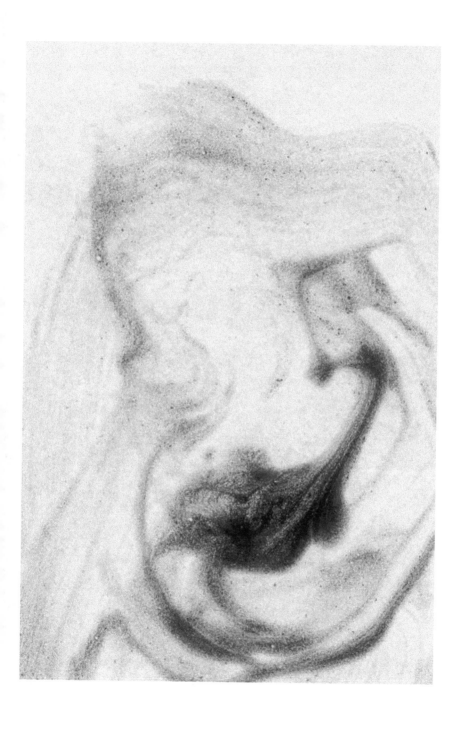

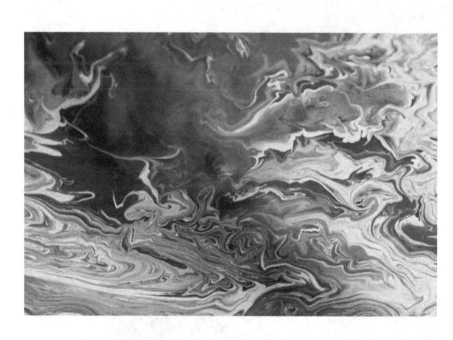

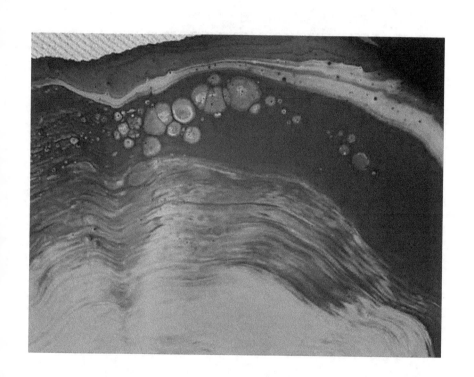

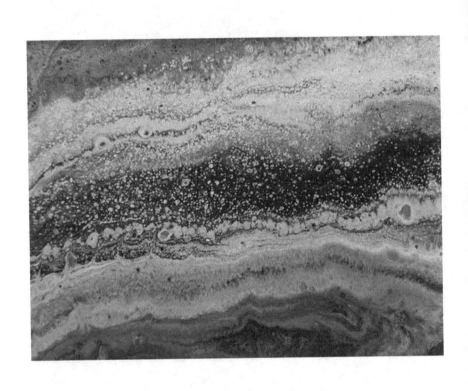

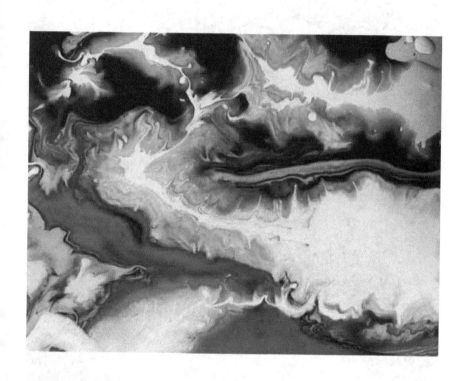

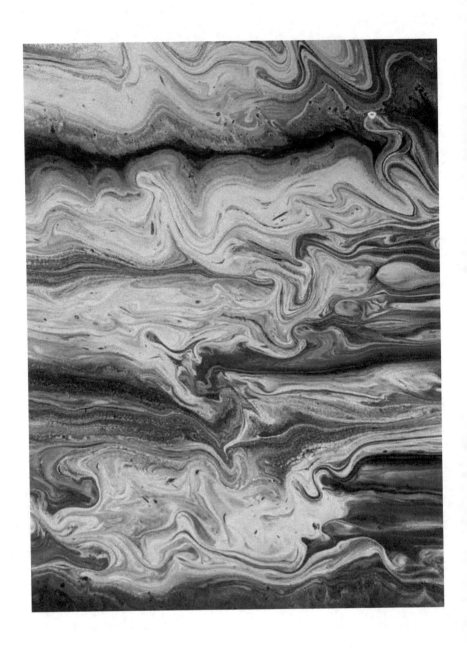

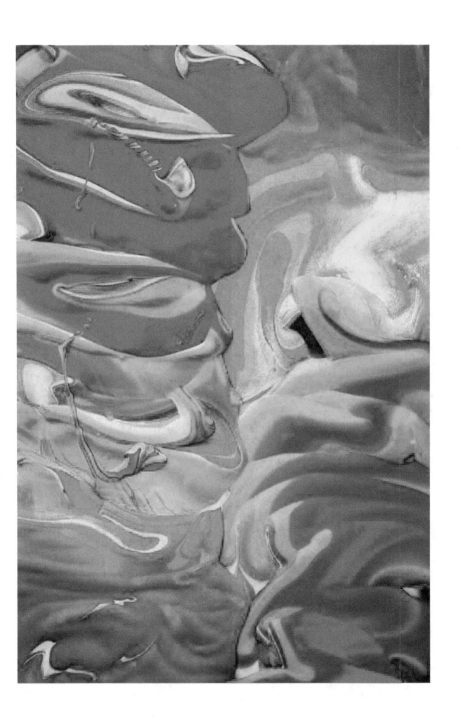

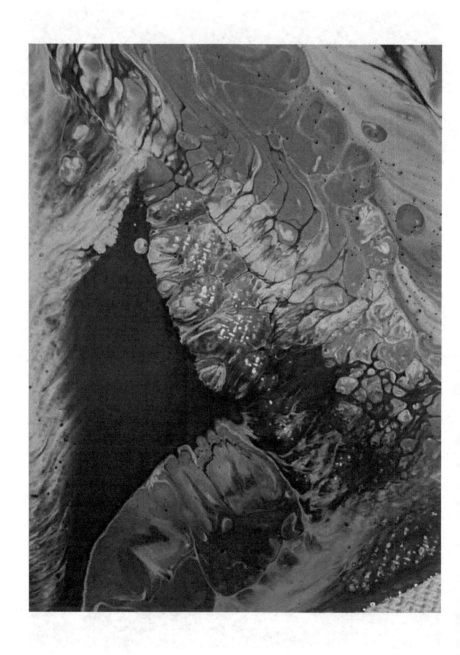

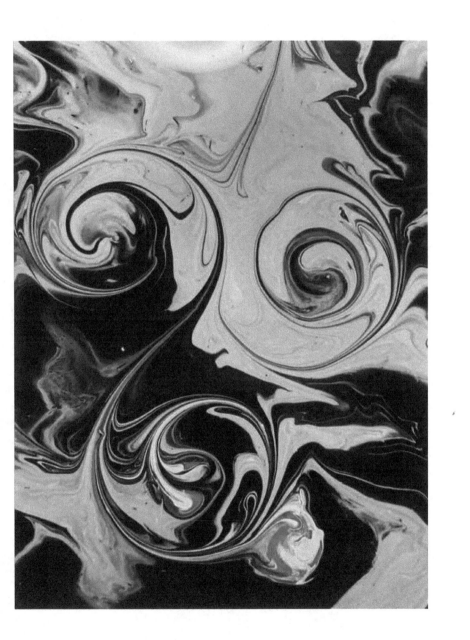

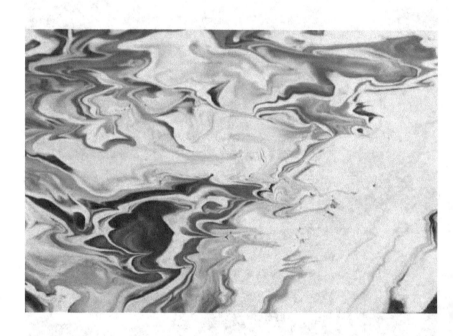

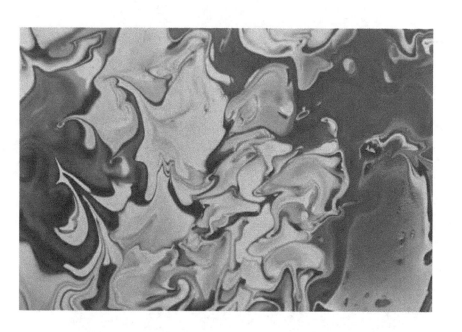

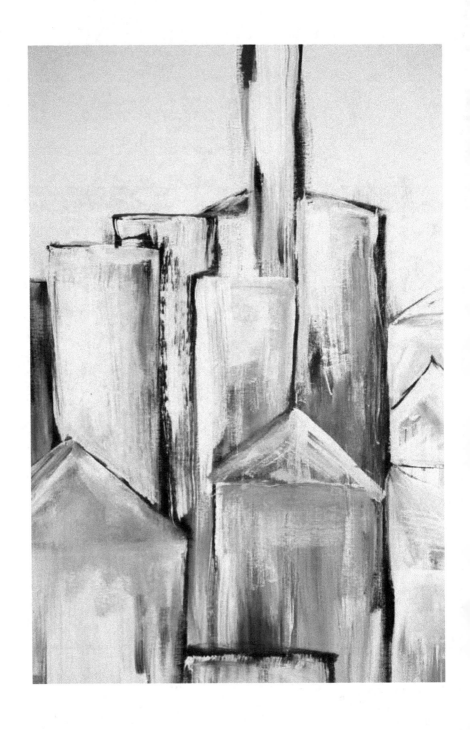

CPSIA information can be obtained
at www.ICGtesting.com
Printed in the USA
BVHW062308140621
609528BV00011B/1855